IN BLACK AND WHITE

IN BLACK
& WHITE

the graphics
of Charles
Tomlinson

with an
introduction by
Octavio Paz

A CARCANET NEW PRESS PUBLICATION

SBN 85635 117 2

First published 1976
by Carcanet New Press Limited
266 Councillor Lane
Cheadle Hulme, Cheadle
Cheshire SK8 5PN

Acknowledgements are due to: *The Christian Science Monitor*, *Plural* (Mexico), and *Prospice* where the three texts by Charles Tomlinson first appeared. Octavio Paz's introduction first appeared in *Poetry Nation V*. Thanks are due to James Lees-Milne for permission to reproduce 'Dragonfly World', and to the Manchester Education Committee for 'Dantescan Landscape' and 'Deep Structure'.

Photographs by Cedric Barker, Bristol

The Publisher acknowledges the financial assistance of the Arts Council of Great Britain.

Printed in Great Britain by
Eyre & Spottiswoode Ltd
at Grosvenor Press, Portsmouth

CONTENTS

The Graphics of Charles Tomlinson
by Octavio Paz 7

Poet as Painter 16

To Begin: notes on Graphics 20

Image and Chance: from a Notebook 21

THE GRAPHICS 23

The Graphics of Charles Tomlinson

When I first read one of Charles Tomlinson's poems, over ten years ago, I was struck by the powerful presence of an element which, later, I found in almost all his creative work, even in the most reflective and self-contemplating: the outer world, a presence at once constant and invisible. It is everywhere but we do not see it. If Tomlinson is a poet for whom 'the outer world exists', it must be added that it does not exist for him as an independent reality, apart from us. In his poems the distinction between subject and object is attenuated until it becomes, rather than a frontier, a zone of interpenetration, giving precedence not to the subject but rather to the object: the world is not a representation of the subject — rather, the subject is the projection of the world. In his poems, outer reality — more than merely the space in which our actions, thoughts and emotions unfold — is a climate which involves us, an impalpable substance, at once physical and mental, which we penetrate and which penetrates us. The world turns to air, temperature, sensation, thought; and we become stone, window, orange peel, turf, oil stain, helix.

Against the idea of the world-as-spectacle, Tomlinson opposes the concept — a very English one — of the world as event. His poems are neither a painting nor a description of the object or its more or less constant properties; what interests him is the process which leads it to be the object that it is. He is fascinated — with his eyes open: a lucid fascination — at the universal busyness, the continuous generation and degeneration of things. His is a poetry of the minimal catastrophes and resurrections of which the great catastrophe and resurrection of the worlds is composed. Objects are unstable congregations ruled alternately by the forces of attraction and repulsion. Process and not transition: not the place of departure and the place of arrival but what we are when we depart and what we have become when we arrive . . . The water-drops on a bench wet with rain, crowded on the edge of a slat, after an instant of ripening — analogous in the

7

affairs of men to the moment of doubt which precedes major decisions — fall on to the concrete; 'dropped seeds of now becoming then'. A moral and physical evocation of the water-drops . . .

Thanks to a double process, at once visual and intellectual, the product of many patient hours of concentrated passivity and of a moment of decision, Tomlinson can isolate the object, observe it, leap suddenly inside it and, before it dissolves, take his snapshot. The poem is the perception of the change, a perception which includes the poet: he changes with the changes of the object and perceives himself in the perception of those changes. The leap into the object is a leap into himself. The mind is a photographic darkroom: there the images — 'the gypsum's snow / the limestone stair / and bone-yard landscape grow / into the identity of flesh' ('The Cavern'). It is not, of course, a pantheistic claim to be every-where and to be everything. Tomlinson does not wish to be the heart and soul of the universe. He does not seek the 'thing in itself' or the 'thing in myself' but rather things in that moment of indecision when they are on the point of generation or degeneration. The moment they appear or disappear before us, before they form as objects in our minds or dissolve in our forgetfulness . . . Tomlinson quotes a passage from Kafka which defines his own purpose admi-rably: 'to catch a glimpse of things as they may have been be-fore they show themselves to me.'

His procedure approaches, at one extreme, science: maxi-mum objectivity and purification, though not suppression, of the subject. On the other hand, nothing is further from mo-dern scientism. This is not because of the aestheticism with which he is at times reproached, but because his poems are experiences and not experiments. Aestheticism is an affecta-tion, contortion, preciosity, and in Tomlinson we find rigor, precision, economy, subtlety. The experiments of modern science are carried out on segments of reality, while expe-riences implicitly postulate that the grain of sand is a world and each fragment figures the whole; the archetype of experi-ments is the quantitative model of mathematics, while in ex-perience a qualitative element appears which up to now has not been limited to measurement. A contemporary mathema-tician, René Thom, describes the situation with grace and

8

exactness: 'A la fin du XVIIième siècle, la controverse faisait rage entre tenants des physiques de Descartes et de Newton. Descartes, avec ses tourbillons, ses atomes crochus, etc., expliquait tout et ne calculait rien; Newton, avec la loi de gravitation en $1/r^2$, calculait tout et n'expliquait rien.' And he adds, 'Le point de vue newtonien se justifie pleinement par son efficacité . . . mais les esprits soucieux de compréhension n'auront jamais, au regard des théories qualitatives et descriptives, l'attitude méprisant du scientisme quantitatif.' It is even less justifiable to undervalue the poets, who offer us not theories but experiences.

In many of his poems Tomlinson presents us with the changes in the particle of dust, the outlines of the stain spreading on the rag, the way the seed's flying mechanism works, the structure of the swirling air current. The experience fulfills a need of the human spirit: to imagine what we cannot see, give ideas a form the senses can respond to, *see* ideas. In this sense the poet's experiences are not less truthful than the experiments carried out in our laboratories, though their truth is on another level from scientific truth. Geometry translates the abstract relationships between bodies into forms which are visible archetypes: thus, it is the frontier between the qualitative and the quantitative. But there is another frontier: that of art and poetry, which translates into sensible forms, that are at the same time archetypes, the qualitative relationships between things and men. Poetry — imagination and sensibility made language — is a crystalising agent of phenomena. Tomlinson's poems are crystals, produced by the combined action of his sensibility and his imaginative and verbal powers — crystals sometimes transparent, sometimes rainbow-coloured, not all perfect, but all poems that we can look through. The act of looking becomes a destiny and a profession of faith: seeing is believing.

It is hardly surprising that a poet with these concerns should be attracted to painting. In general, the poet who turns to painting tries to express with shapes and colours those things he cannot say with words. The same is true of the painter who writes. Arp's poetry is a counterpointing of wit and fantasy set against the abstract elegance of his plastic work. In the case of Michaux, painting and drawing are essentially rhythmic incantations, signs beyond articulate

9

language, visual magic. The expressionism of some of Tagore's ink drawings, with their violence, compensates us for the sticky sweetness of many of his melodies. To find one of Valery's water-colours among the arguments and paradoxes of the *Cahiers* is like opening the window and finding that, outside, the sea, the sun and the trees still exist. When I was considering Tomlinson, I called to mind these other artists, and I asked myself how this desire to paint came to manifest itself in a meditative temperament such as his — a poet whose main faculty of sense is his eyes, but eyes which think. Before I had a chance to ask him about this, I received, around 1970, a letter from him in which he told me he had sent me one of the *New Directions Anthologies*, which included reproductions of some of his drawings done in 1968. Later in 1970, during my stay in England, I was able to see other drawings from that same period — all of them in black and white, except for a few in sepia; studies of cow skulls, skeletons of birds, rats and other creatures which he and his daughters had found in the countryside and on the Cornish beaches.

In Tomlinson's poetry, the perception of movement is exquisite and precise. Whether the poem is about rocks, plants, sand, insects, leaves, birds or human beings, the true protagonist, the hero of each poem, is change. Tomlinson hears foliage grow. Such an acute perception of variations, at times almost imperceptible, in beings and things, necessarily implies a vision of reality as a system of calls and replies. Beings and things, in changing, come in contact: change means relationship. In those Tomlinson drawings, the skulls of the birds, rats and cows were isolated structures, placed in an abstract space, far from other objects, and even at a remove from themselves, fixed and immovable. Rather than a counterpointing of his poetic work, they seemed to me a contradiction. He missed out some of the features which attract me to his poetry: delicacy, wit, refinement of tones, energy, depth. How could he recover all these qualities without turning Tomlinson the painter into a servile disciple of Tomlinson the poet? The answer to this question is found in the work — drawings, collages and decalcomania* — of recent years.

* 'Decalcomania without preconceived object or decalcomania of desire: by means of a thick brush, spread out black gouache, more or less diluted in places, upon a sheet of glossy white paper, and cover at once with a second sheet, upon which exert an even pressure. Lift off the second sheet without haste.' Oscar Dominguez, quoted in *Surrealism* by Roger Cardinal and Robert Stuart Short.

Tomlinson's painting vocation began, significantly, in a fascination with films. When he came down from Cambridge in 1948, he had not only seen 'all the films'; he was also writing scripts which he sent to producers and which they, invariably, returned to him. This passion died out in time but left two enduring interests: in the image in motion, and in the idea of a literary text as support for the image. Both elements reappear in the poems and the collages. When the unions closed the doors of the film industry against him, Tomlinson dedicated himself energetically to painting. His first experiments, combining *frottage*, oil and ink, date from that period. Between 1948 and 1950 he exhibited his work in London and Manchester. In 1951 he had the opportunity to live for a time in Italy. During that trip the urge to paint began to recede before the urge to write poetry. When he returned to England, he devoted himself more and more to writing, less and less to painting. In this first phase of his painting, the results were indecisive: *frottages* in the shadow of Max Ernst, studies of water and rocks more or less inspired by Cézanne, trees and foliage seen in Samuel Palmer rather than in the real world. Like other artists of his generation, he made the circuit round the various stations of modern art and paused, long enough to genuflect, before the geometric chapel of the Braques, the Légers and the Gris's. During those same years — getting on towards 1954 — Tomlinson was writing the splendid *Seeing is Believing* poems. He ceased painting.

The interruption was not long. Settled near Bristol, he returned to his brushes and crayons. The temptation to use black (why? he still asks himself) had an unfortunate effect: by exaggerating the contours, it made his compositions stiff. 'I wanted to reveal the pressure of objects,' he wrote to me, 'but all I managed to do was thicken the outlines.' In 1968 Tomlinson seriously confronted his vocation and the obstacles to it. I refer to his inner inhibitions and, most of all, to that mysterious predilection for black. As always happens, an intercessor appeared: Seghers. Tomlinson was wise to have chosen Hercules Seghers — each of us has the intercessors he deserves. It is worth noting that the work of this great artist — I am thinking of his impressive stony landscapes done in white, black and sepia — also inspired Nicolas de Staël.

Segher's lesson is: do not abandon black, do not resist it, but embrace it, walk round it as you walk round a mountain. Black was not an enemy but an accomplice. If it was not a bridge, then it was a tunnel: if he followed it to the end it would bring him through to the other side, to the light. Tomlinson had found the key which had seemed lost. With that key he unlocked the door so long bolted against him and entered a world which, despite its initial strangeness, he soon recognised as his own. In that world black ruled. It was not an obstacle but an ally. The ascetic black and white proved to be rich, and the limitation on the use of materials provoked the explosion of forms and fantasy.

In the earliest drawings of this period, Tomlinson began with the method which shortly afterwards he was to use in his collages: he set the image in a literary context and thus built up a system of visual echoes and verbal correspondences. It was only natural that he should have selected one of Mallarmé's sonnet in which the sea snail is a spiral of resonances and reflections. The encounter with surrealism was inevitable — not to repeat the experiences of Ernst or Tanguy but to find the route back to himself. Perhaps it would be best to quote a paragraph of the letter I mentioned before: 'Why couldn't I make their world my world? But in my own terms. In poetry I had always been drawn to impersonality — how could I go beyond the self in painting?' Or put another way: how to use the surrealists' psychic automatism without lapsing into subjectivism? In poetry we accept the accident and use it even in the most conscious and premeditated works. Rhyme, for example, is an accident; it appears unsummoned but, as soon as we accept it, it turns into a choice and a rule. Tomlinson asked himself: what in painting is the equivalent of rhyme in poetry? What is *given* in the visual arts? Oscar Domínguez answered that question with his decalcomania. In fact, Domínguez was a bridge to an artist closer to Tomlinson's own sensibility. In those days he was obsessed by Gaudí and by the memory of the dining-room windows in Casa Batlló. He drew them many times: what would happen if we could look out from these windows onto the landscape of the moon?

Those two impulses, Domínguez's decalcomania and Gaudí's architectural arabesques, fused: 'Then, I conceived of

the idea of cutting and contrasting sections of a sheet of decalcomania and fitting them into the irregular window-panes . . . Scissors! Here was the instrument for choice. I found I could *draw* with scissors, reacting *with* and *against* the decalcomania . . . Finally I took a piece of paper, cut out the shape of Gaudí's window and moved this mask across my decalcomania until I found my moonscape . . . The 18th of June 1970 was a day of discovery for me: I made my best arabesque of a mask, fitted it round a paint blot and then extended the idea of reflection implicit in the blot with geometric lines . . .' Tomlinson had found, with different means from those he used in his poetry but with analogous results, a visual counterpoint for his verbal world: a counterpointing and a complement.

The quotations from Tomlinson's letter reveal with involuntary but overwhelming clarity the double function of the images, be they verbal or visual. Gaudí's windows, converted by Tomlinson into masks, that is, into objects which *conceal*, serve him to *reveal*. And what does he discover through those window-masks? Not the real world: an imaginary landscape. What began on the 18th of June 1970 was a fantastic morphology. A morphology and not a mythology: the places and beings which Tomlinson's collages evoke for us reveal no paradise or hell. Those skies and those caverns are not inhabited by gods or devils; they are places of the mind. To be more exact, they are places, beings and things revealed in the dark-room of the mind. They are the product of the confabulation — in the etymological sense of that word — of accident and imagination.

Has it all been the product of chance? But what is meant by that word? Chance is never produced by chance. Chance possesses a logic — is a logic. Because we have yet to discover the rules of something, we have no reason to doubt that there are rules. If we could outline a plan, however roughly, of its involved corridors of mirrors which ceaselessly knot and unknot themselves, we would know a little more of what really matters. We would know something, for instance, about the intervention of 'chance' both in scientific discoveries and artistic creation and in history and our daily life. Of course, like all artists, Tomlinson knows something: we ought to accept chance as we accept the appearance of an

unsummoned rhyme.

In general, we should stress the moral and philosophical aspect of the operation: in accepting chance, the artist transforms a thing of fate into a free choice. Or it can be seen from another angle: rhyme guides the text but the text produces the rhyme. A modern superstition is that of art as transgression. The opposite seems to me truer: art transforms disturbance into a new regularity. Topology can show us something: the appearance of the accident provokes, rather than the destruction of the system, a recombination of the structure which was destined to absorb it. The structure validates the disturbance, art canonises the exception. Rhyme is not a rupture but a binding agent, a link in the chain, without which the continuity of the text would be broken. Rhymes convert the text into a succession of auditory equivalences, just as metaphors make the poem into a texture of semantic equivalences. Tomlinson's fantastic morphology is a world ruled by verbal and visual analogies.

What we call chance is nothing but the sudden revelation of relationships between things. Chance is an aspect of analogy. Its unexpected advent provokes the immediate response of analogy, which tends to integrate the exception in a system of correspondences. Thanks to chance we discover that silence is milk, that the stone is composed of water and wind, that ink has wings and a beak. Between the grain of corn and the lion we sense no relationship at all, until we reflect that both serve the same lord: the sun. The spectrum of relationships and affinities between things is extensive, from the interpenetration of one object with another —'the sea's edge is neither sand nor water', the poem says — to the literary comparisons linked by the word 'like'. Contrary to surrealist practice, Tomlinson does not juxtapose contradictory realities in order to produce a mental explosion. His method is more subtle. And his intention is distinct from theirs: he does not wish to alter reality but to achieve a *modus vivendi* with it. He is not certain that the function of imagination is to transform reality; he is certain, on the other hand, that it can make it more real. Imagination imparts a little more reality to our lives.

Spurred on by fantasy and reined in by reflection, Tomlinson's work submits to the double requirements of

14

imagination and perception: one demands freedom and the other precision. His attempt seems to propose for itself two contradictory objectives: the saving of appearances, and their destruction. The purpose is not contradictory because what it is really about is the rediscovery — more precisely, the re-living — of the original act of making. The experience of art is one of the the experiences of Beginning: that archetypal moment in which, combining one set of things with another to produce a new, we reproduce the very moment of the making of the worlds. Intercommunication between the letter and the image, the decalcomania and the scissors, the window and the mask, those things which are hardlooking and those which are softlooking, the photograph and the drawing, the hand and the compass, the reality which we see with our eyes and the reality which closes our eyes so that we see it: the search for a lost identity. Or as Tomlinson puts it best: 'to reconcile the I that is with the I that I am'. In the nameless, impersonal I that is, are fused the I that measures and the I that dreams, the I that thinks and the I that breathes, the I which creates and the I which destroys.

Octavio Paz
Cambridge, Massachusetts
January 6, 1975

15

Poet as Painter

The fact that 'chance' rhymes with 'dance' is a nutrifying thought for the artist, whether he is a poet or a painter. There seems no intrinsic reason why these two words should have much to do with each other. And there seems no intrinsic reason, either, why the strokes of a brush covered in pigment, or the dashes, slashes or dots a painter makes, should have much to do with a face, a landscape, a stone or a skull.

Yet chance does rhyme with dance, and meditation on the fact undoubtedly feeds the mind: chance occurrences, chance meetings invade what we do every day and yet they are drawn into a sort of pattern, as they criss-cross with our feeling of what we are, as they remind us of other happenings, or strengthen our sense of future possibility. Poetry is rather like this, also. Something fortuitous sets it off — a title, say, out of the blue, asking for a poem to go with it, a title like 'The Chances of Rhyme', and you find yourself writing on the back of an envelope:

> The chances of rhyme are like the chances of meeting —
> In the finding fortuitous, but once found, binding . . .

Already you have started to knit up those chances, with 'finding' and 'binding' reinforcing the pattern, and before long the chances of rhyme are becoming the continuities of thought:

> To take chances, as to make rhymes
> Is human, but between chance and impenitence
> (A half rhyme) come dance, vigilance
> And circumstance . . .

Yes, that makes sense. It seems to be getting somewhere: a pattern in the words, a pattern in the thought, a pattern in the way the line settles mostly for four main stresses, sometimes stretches to five, mostly dances back to four.

You cannot do this sort of thing with paint. The medium is very different. You may write with a pencil, but once you

16

come to draw with it, what a diverse end those marks serve. But the fortuitous element is still there — the element of meeting something you didn't expect, something that isn't yourself. And once you attend to it, whatever you are starts to see an interesting challenge to its own relaxed complacency. Quite by accident you find, on a beach, the skull of a sea bird, for instance. You could put it in a glass cabinet or forget it in a safe place, but instead you draw it. You begin to know far more about the structure of that particular skull, as eye and pencil try to keep up with each other.

There is a lot, though, you can't know about — the mysterious darkness of its interior, the intriguing and impenetrable holes and slots where something or other has now rotted away and left a clean emptiness. The cleanliness, the natural geometry of the skull suggest the idea of surrounding it in a geometry of your own — carefully ruled lines that set off the skull, that extend it, that bed it in a universe of contrasting lines of force. Just as rhyme dancing with thought led you through to a world of human values, so skull and line build up and outwards into a containing universe.

Now, there is something very resistant about this skull. You feel you could etch a very tiny poem on it called, perhaps, 'To be Engraved on the Skull of a Cormorant'. To do so you would have to be both tough and careful with it —

> . . . as searching as the sea
> that picked and pared
> this head yet spared
> its fragile acuity.

And so a poem comes out of this find, too. But that interior darkness goes on bothering you. How could I relate it, you think, to the little universe my lines netted together around it?

This particular problem was solved by forgetting about it. Or by seeming to forget and doing something else. Three years after drawing 'Long-Beaked Skull', I did 'The Sleep of Animals': here the skulls are filled by a dream of the landscapes the bird and animal presences have been moving through. The dream articulates the darkness. There is a whole world in each head. There is the suggestion that this sleep is,

17

perhaps, death in which both the head and nature are now one.

In writing poetry, you sometimes run aground on silence, and it takes months or sometimes years to learn what it is you wish to say. In the meantime, you are half-consciously turning the problem over, while, at the same time, furthering the knowledge of your medium. Among the techniques I had worked with between 'Long-Beaked Skull' and 'The sleep of Animals' were collage and what the surrealists called decalcomania. This latter consists of crushing diluted paint between two surfaces, then using the chance forms of the pigment as a suggestive basis for a new picture. I suddenly saw something rather like — though not yet *much* like — two skulls merged in the landscape of my decalcomania. Instead of continuing to paint, I cut out the skulls with scissors, glued new shapes onto them, then fitted them into a quite rigorous design held together by ruled lines. I realised I had discovered an answer to the dark, unenterable interior of that first bird's skull. My answer seemed to have arrived instantaneously, but — again like poetry — the formal pattern had taken up chance elements, had been the result of conscious and sub-conscious processes and of that strange, unifying moment of recognition when, reaching for the scissors, what I'd found became what I'd chosen. 'Chance' rhymed with 'dance' once more.

In both graphic and poetic art, I like something lucid surrounded by something mysterious. In 'Origin of the Milky Way' and 'The Dry Salvages', the first with its cosmic setting, the second with its seascape, I have tried to push outwards from the contained forms of the skulls — my own skull, perhaps. I see poems and pictures as the place where the civilised, discriminating faculties and the sense of the elemental, of origins, reinforce each other. I go back, time and again, to the idea of a seascape

> with illegible depths
> and lucid passages,
> bestiary of stones,
> book without pages . . .

and a poem seems to be composing itself that could well be a picture, a picture that could well be a poem. When words

18

seem too abstract, then I find myself painting the sea with the very thing it is composed of — water, and allowing its thinning and separation of the pigment to reveal an image of its own nature.

To begin: Notes on Graphics

To begin beyond the self. To comply with paint, water and paper. To be led by the hand. To let the hand lead. To reconcile the I that is and the I that I am.

To enter the world of images and, thereby, to be entered by them. To experience the primordial in the given, the archetypal in the concrete. To be possessed by ungovernable presences, and render through paint that invasion coming from outside, as when:

> . . . huge and mighty forms, that do not live
> Like living men, moved slowly through my mind
> By day, and were the trouble of my dreams.
> *(Prelude* I, 425-7)

But to reflect the lightness as well as the hauntings, the currents of air, the translucencies as well as the resistances, the offscape as well as the faces of the stones.

One recognises and one pursues: string-prints, hand-prints, finger-tips in the paint open into caves, burrows, waters, a world to be tracked, followed through.

The content is in the paint and in its minglings with water: the mind passes through them, led by the hand, and the form arises within the mind while being embodied, housed, stilled in the paint.

To return through materials to origins. At the centre of Paul Klee's *On Modern Art* stands the passage concerning Genesis, the artist 'impressed by the one essential image of creation itself, as Genesis, rather than by the image of nature, the finished product . . . He sees the act of world creation stretching from the past to the future. Genesis eternal!'

So Genesis is discovery in the act of making, and thus one aspect of the art of our time is that it is an art of improvisation, the finished picture containing within itself its own preliminary sketch. Or, as Pasternak says in *Safe Conduct*: 'The best of the world's productions, while telling of the most diverse things, are in fact recounting their own birth.'

To begin . . . and with that constant longing, perhaps, of the young man in Kafka's story, 'to catch a glimpse of things as they may have been before they show themselves to me.'

20

Image and Chance: From a Notebook

Constable admired chance because it was governed by laws — accidents of cloud cover, tricks of light. He permitted the weather to re-make his style by its calling into question those schemata he already knew. It was not a choice. The choice was involved in bringing to bear a technique capable of embodying such questioning. Nor was that a choice, either, in so far as it was unconditional, an assent of temperament. Or, if you like, he chose to be taught by chance.

Wordsworth, aware of one of the anomalies in those schemata artists use, expresses it not in terms of visual art but of life:

> I still
> At all times had a real solid world
> Of images about me . . .

'Solid world' — there is a catch of breath at the discrepancy — 'Of images'. It was Magritte wrote under the (painted) image of a pipe, 'This is not a pipe'. It was the solid image of a pipe.

The art of our century has often, perhaps principally, been an investigation of the nature of the image, whether in the visionary realism of Cézanne or the later dérèglement raisonné of (say) Ernst. With Ernst the accidental, by supplying the artist with images, as in his use of decalcomania, makes us ask what this 'solidity' is, even as we accept it.

Constable waited on chance, Ernst created it.

Perhaps Dalí's best picture — or, at any rate, the least distorted by personality — is the one he did not paint: the image of a Picasso head seen in the sideways-on photograph of a kraal, with figures seated outside forming the 'shading' for eyes, nose and mouth (*Minotaure*, no. 3, 1931). For once, Dalí escaped himself — by chance.

'The dream' is only one of the possibilities of decalcomania — and is often no more than an excuse for whimsy (Domínguez's bicycle becoming a lion). Why should decalcomania not be taken as far towards the threshold of perception as it has been towards fantasy?

Max Ernst becomes Walt Disney when his 'disorientation'

(Breton's word) leads merely to those coy monsters that tease St. Anthony. A true disorientation makes visible rather than makes fanciful.

As to 'the dream', there is David Antin's remark that, 'its strangeness is really that of schematically or falsely recalled yet recognisable images . . . The dream was nothing other than a rallying cry for Surrealism and in most cases is totally irrelevant to its actual achievement.' ('Allan D'Arcangelo and the New Landscape', *Art and Literature*, no. 9, 1966.) In the same article, he speaks of Magritte's paintings as 'perpetual motion machines oscillating between pairs of mutually contradictory images. He bears down upon the fragility of the mind itself, seeking the place where the image tears apart . . . '

Yet to try the mind beyond a certain point — or the retina with those painted simulations of migraine — is a sterile pursuit: the image can be of an inclusiveness that not only questions (or registers anomally), but feels out the actual grain of perception. And whether it occupies the threshold of perception or the impossible, it can interpret and confirm the inexhaustible range of a daily act. It tells us what we do and are blind to.

Visual art: not an unleasher of 'the subconscious', but a cure for blindness.

The Graphics of Charles Tomlinson

The Plates

1 Skull Shadows (1.vii.68)
2 Blunt Skull (30.vii.68)
3 Horizontal Skull (4.viii.68)
4 Long-Beaked Skull (8.x.68)
5 Débat avec Mallarmé (11.x.68)
6 Ptyx Utile (21.x.68)
7 Object Lesson (23.vi.70)
8 Feathered Amazonian Butterfly (24.vi.70)
9 Cloudhead (4.vii.70)
10 Land and Water (31.ix.70)
11 Land and Water (31.ix.70)
12 Water and Sky (4-8.x.70)
13 Water and Sky (4-8.x.70)
14 Composition (1-2.x.70)
15 Ode to the West Wind (13.x.70)
16 Between Sea and Sky (17.x.70)
17 The Four Elements (24.x.70)
18 Dragonfly World (3.xi.70)
19 Marine (16.xi.70)
20 Marine III (19.xi.70)
21 Forest Fire (26-28.xi.70)
22 Into Distance (28.xi.70)
23 Deep Structure (25.i.71)
24 The Anatomy of Manna (1.ii.71)
25 Origin of the Milky Way (19.ii.71)
26 The Milk of Silence (21.ii.71)
27 Petrifaction of Manna (28.iii.71)
28 Landscape with Bathers (19.v.71)
29 The Willendorf Grotto (23.vi.71)
30 Stone Chronos (17.vii.71)
31 The Sleep of Animals (20.vii.71)
32 The Underwater Bird (7.xii.71)
33 Cut Out (4.i.72)
34 Dantescan Landscape (1.iii.72)
35 The Fortunate Fall (2.iii.72)
36 Senza più Peso (4.v.72)
37 Not Guilty (26.vi.72)
38 The Thaw (3.ix.72)
39 Clair de Lune (4.ix.72)

40 Peak (15.ix.72)
41 Black and White Landscape (16.ix.72)
42 Skye Landscape (21.ix.72)
43 Two Stones (22.ix.72)
44 Seal it in Seacaves (1.iii.73)
45 The Storm (8.iii.73)
46 The Dry Salvages (24-29.iii.73)
47 Ode to Joy (3.v.73)
48 The Survivors (27.v.73)
49 Three Prehistoric Masks (28.v.73)
50 Threatened Fruit (31.v.73)
51 The Embalmer (20.vii.73)
52 The Embalmer's Apprentice (21.vii.73)
53 Ab Ovo (3.ix.73)

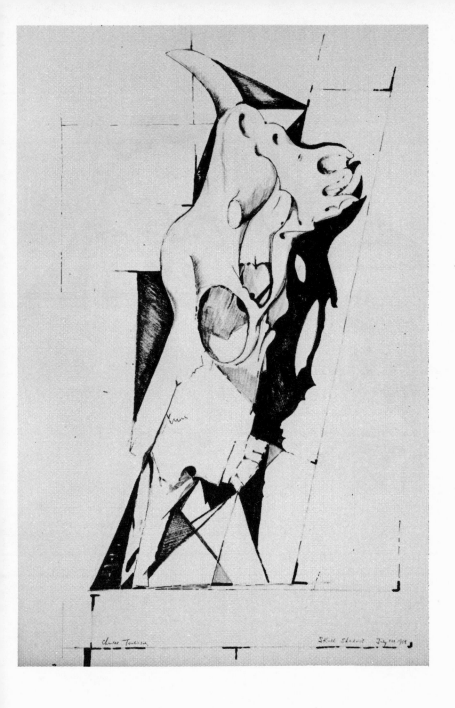

Charles Townsend Skull Sketch July 10, 1915

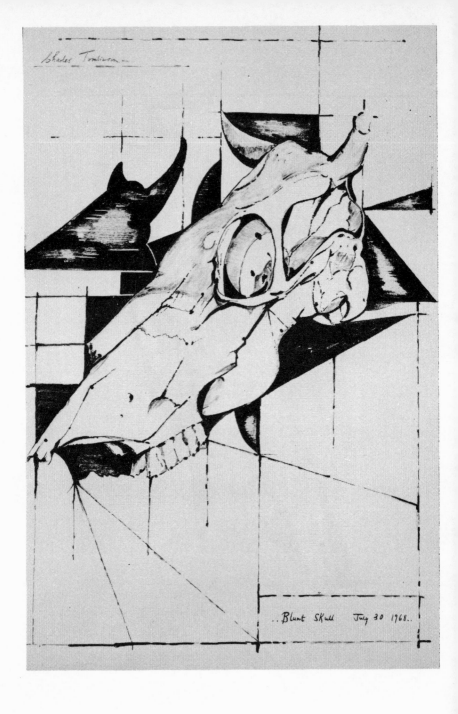

Charles Tomlinson

..Blunt Skull July 30 1768..

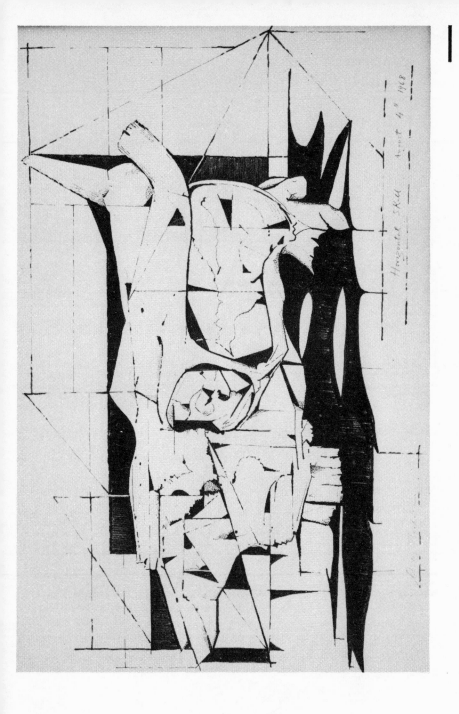

Horizontal Skull August 4th 1948

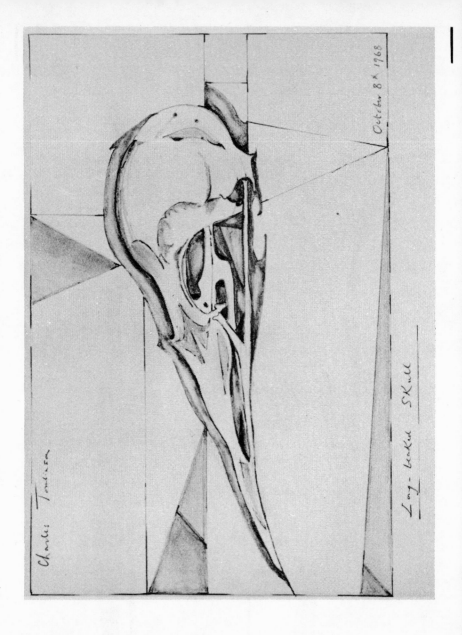

Charles Tunnicliffe

October 8th 1968

Long-beaked Skull

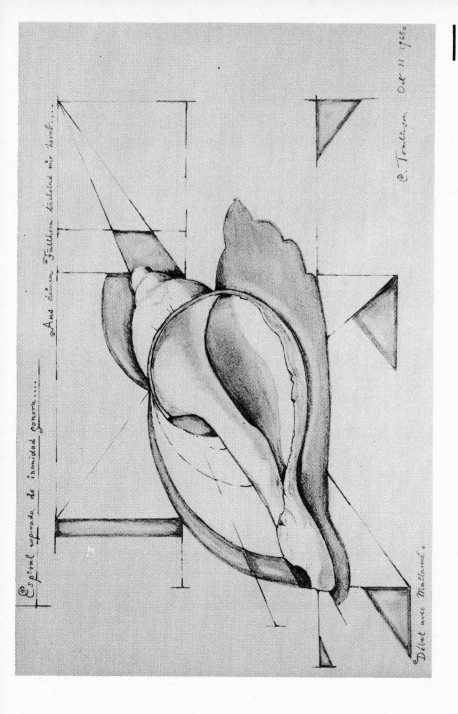

Espiral esperada de inmidad genera......

Aus dichm Fülllhorn dichtern mir tarab......

© Toulouse Oct 11 1986

Débat avec Mallarmé.

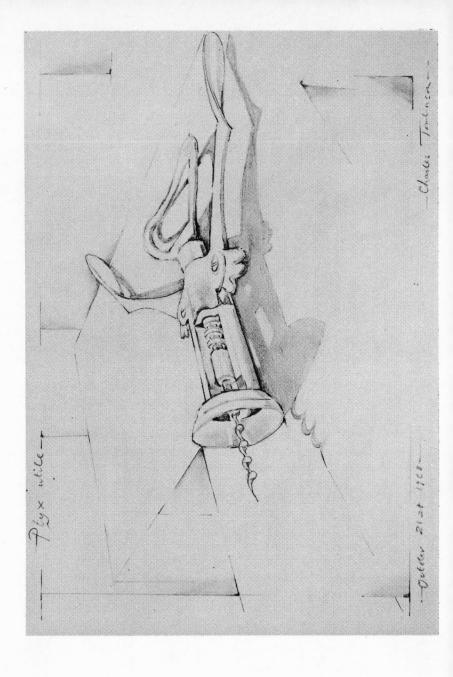

Plyx utile

October 21st 1966

Charles Tomlinson

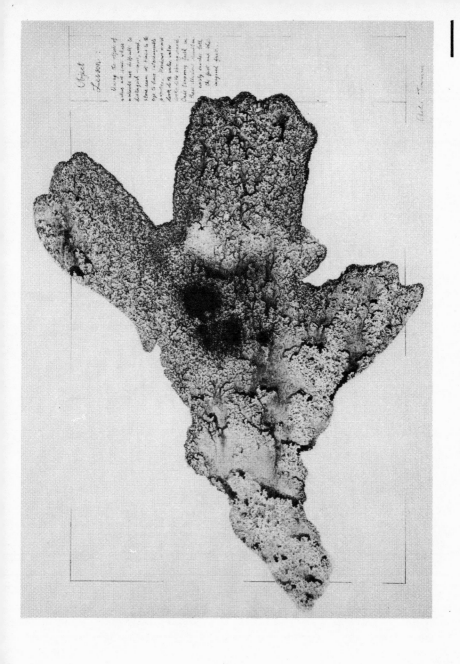

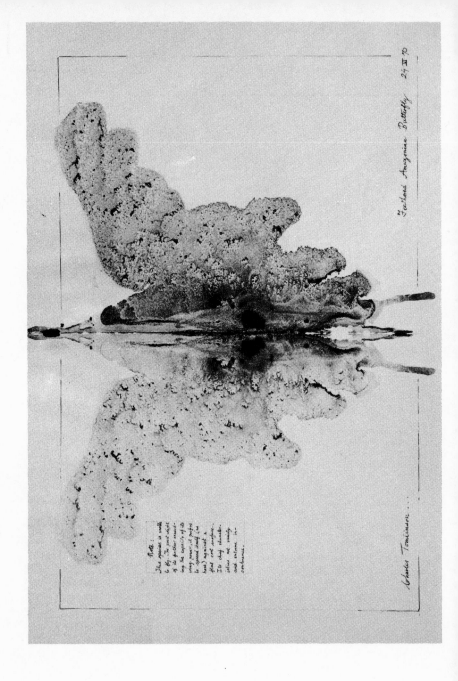

Feathered Amazonian Butterfly 27 II 70

Charles Tomlinson

Note:

[handwritten note, largely illegible]

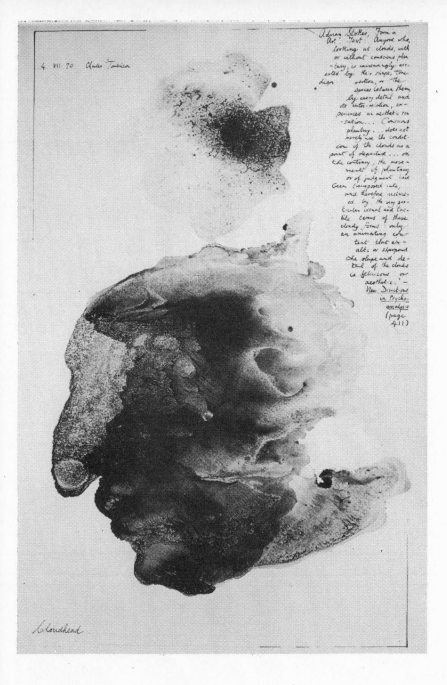

4. VII. 70 Charles Tomlinson

Adrian Stokes, from a
Art Text. Anyone who,
looking at clouds, with
or without conscious plea
-sure, is increasingly arr-
ested by their shape, their
disp osition, or the
 spaces between them
 by every detail and
 its inter-relation, ex-
 periences an aesthetic sen-
 -sation... Conscious
 phantasy... does not
 merely use the condit-
 ion of the clouds as a
 point of departure... on
 the contrary, the move-
 ment of phantasy
 or of judgment had
 been transposed into,
 and therefore restrict-
 ed by the very par-
 ticular visual and tac-
 tile terms of these
 cloudy forms: only
 an animating con-
 tent that ex-
 alts, or sharpens
 the shape and de-
 tail of the clouds
 is felicitous, or
 aesthetic. —
 New Directions
 in Psycho-
 analysis
 (page
 411)

Cloudhead

9

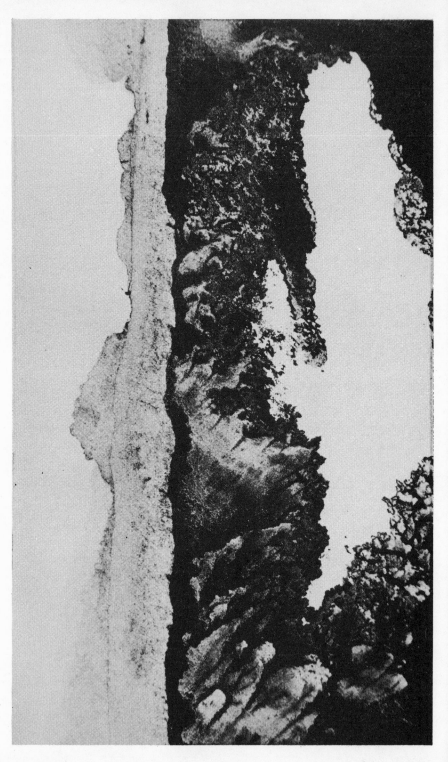

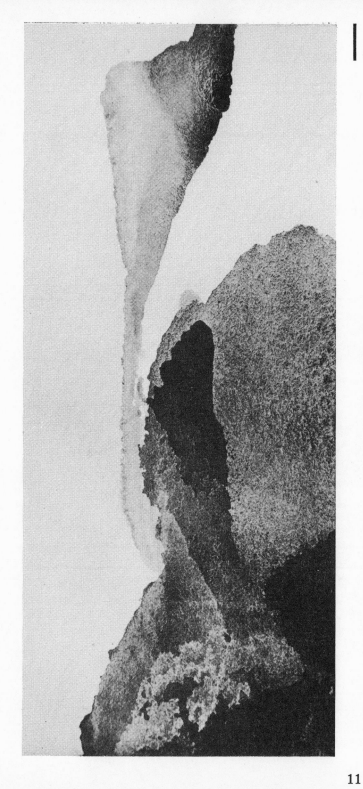

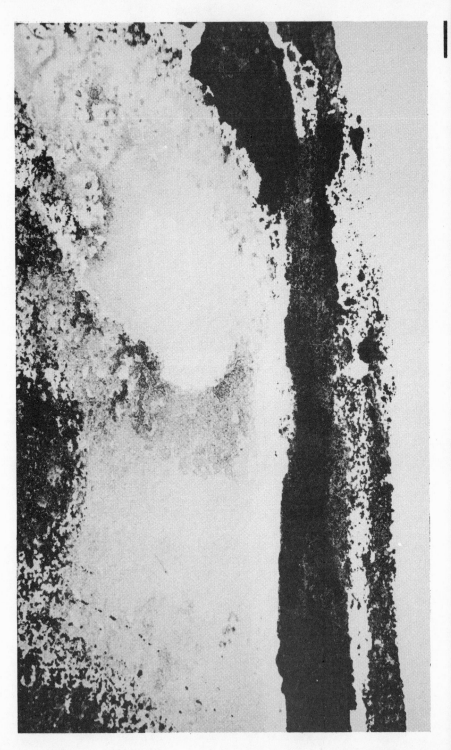

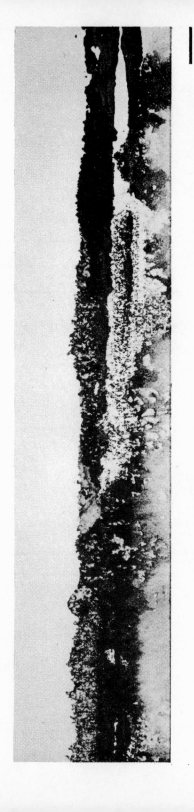

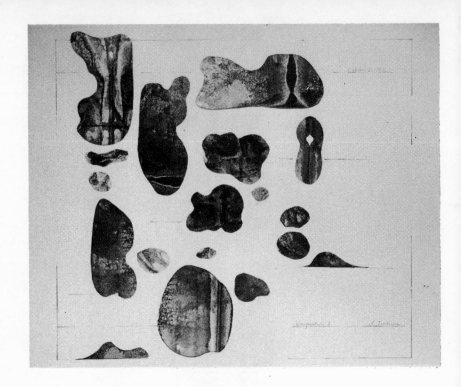

14

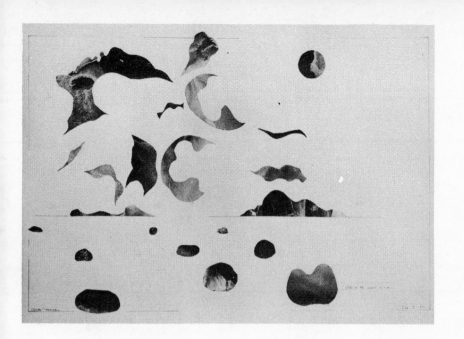

15

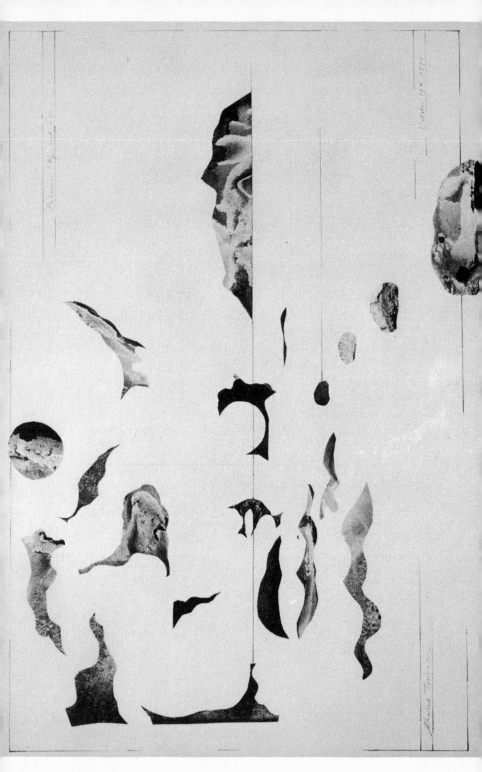

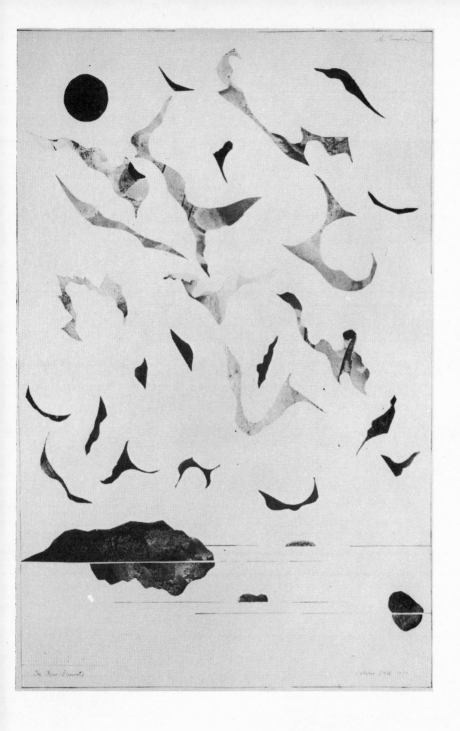

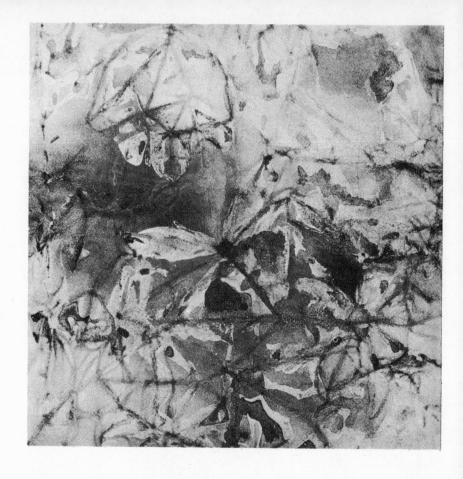

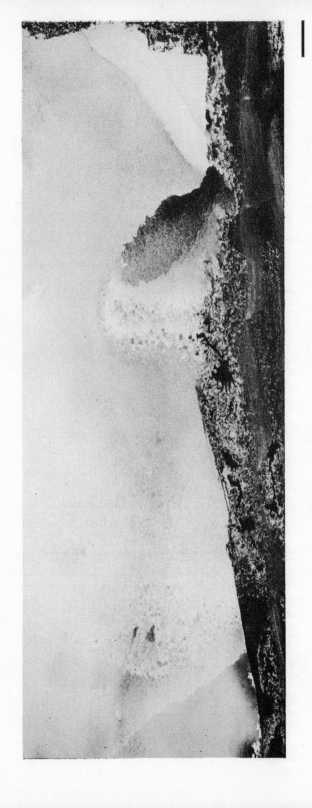

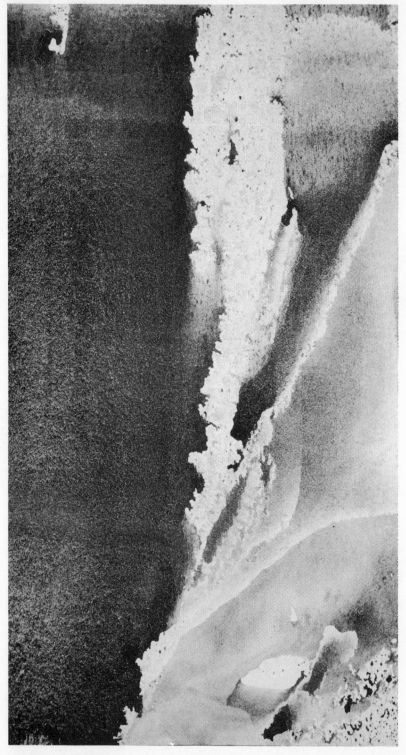

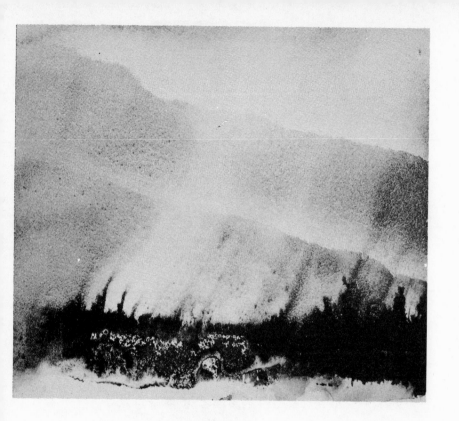

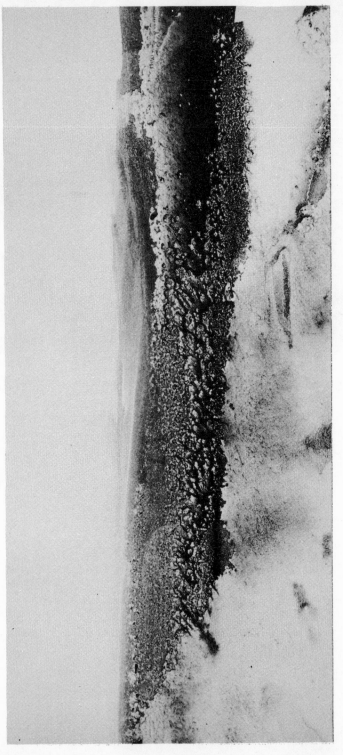

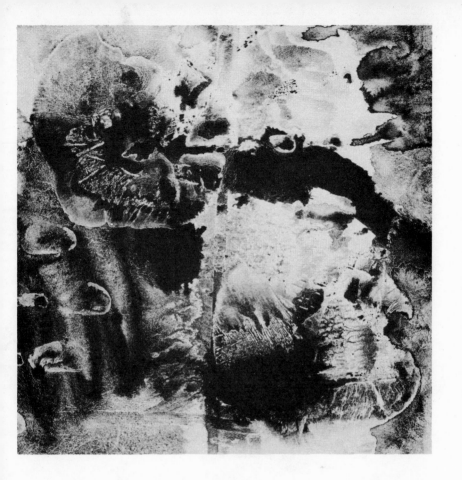

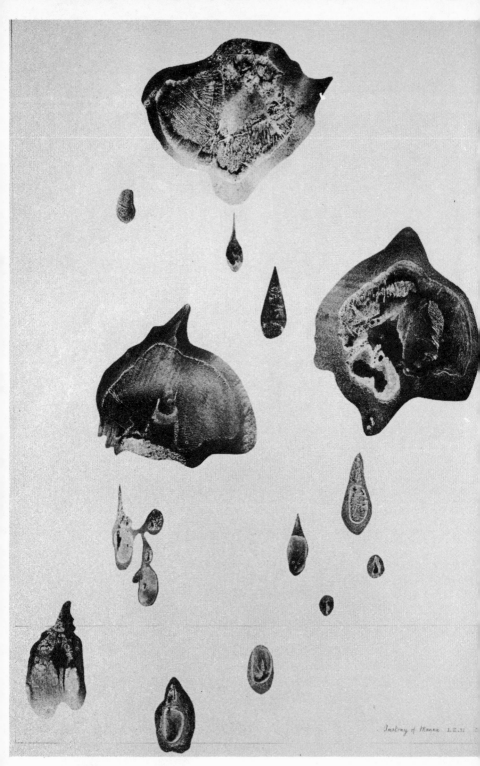

Drawing of Manna L.E.76

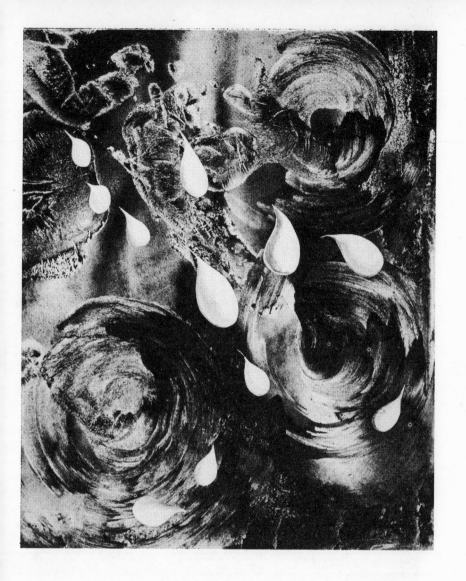

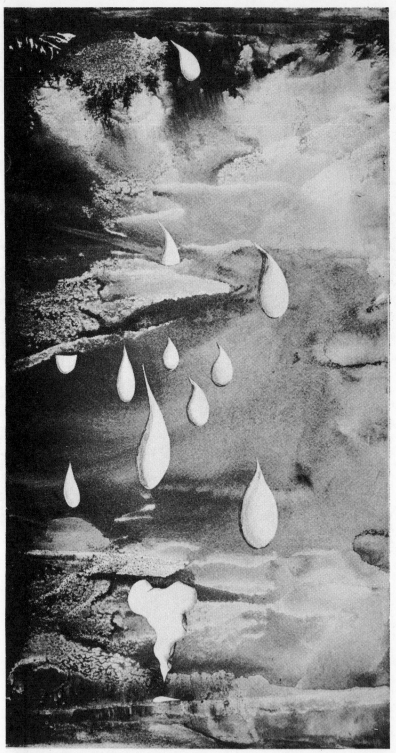

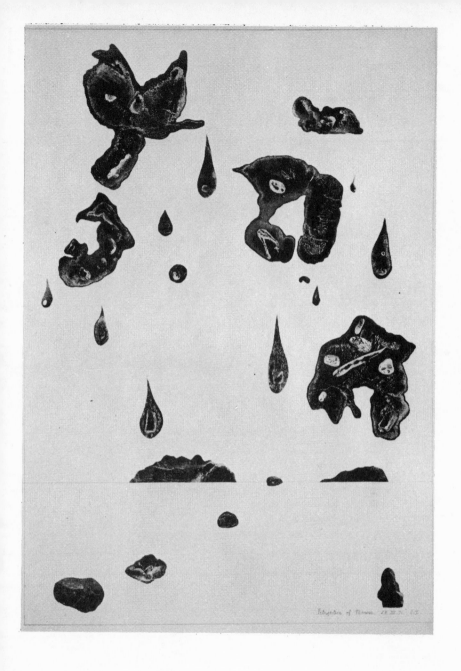

27

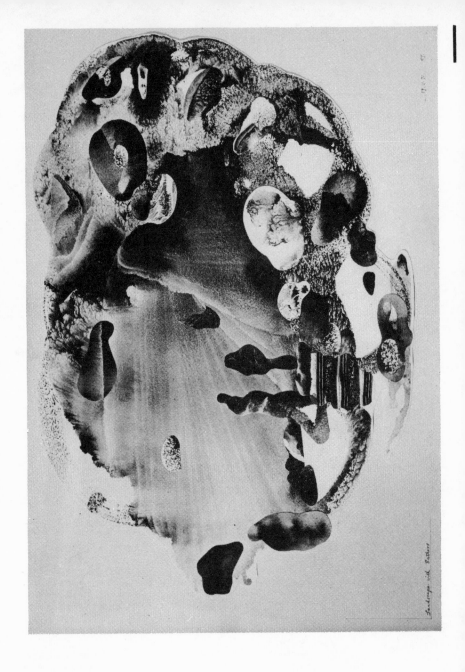

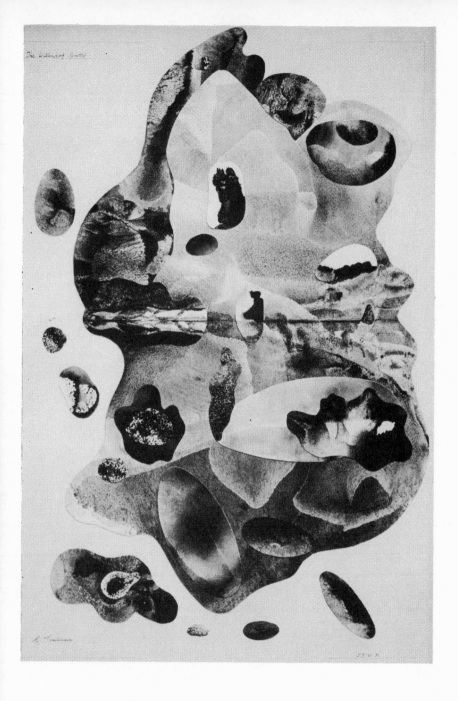

The Wildered Grotto

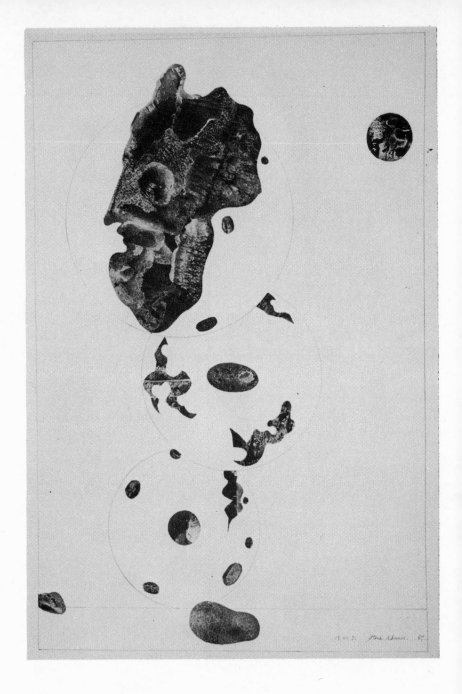

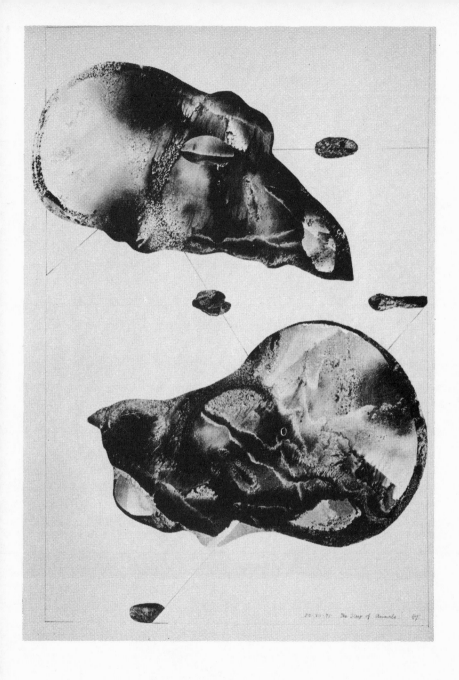

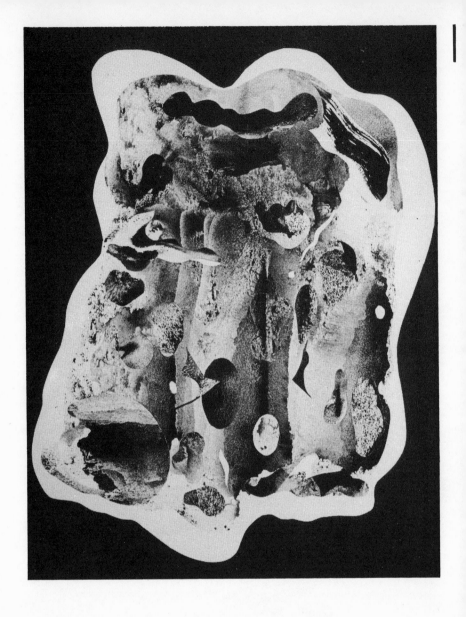

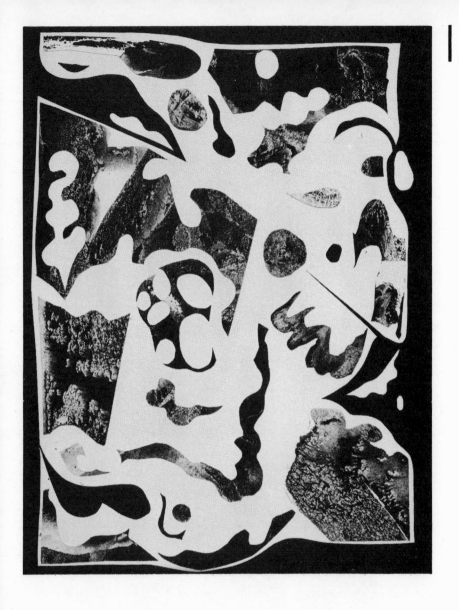

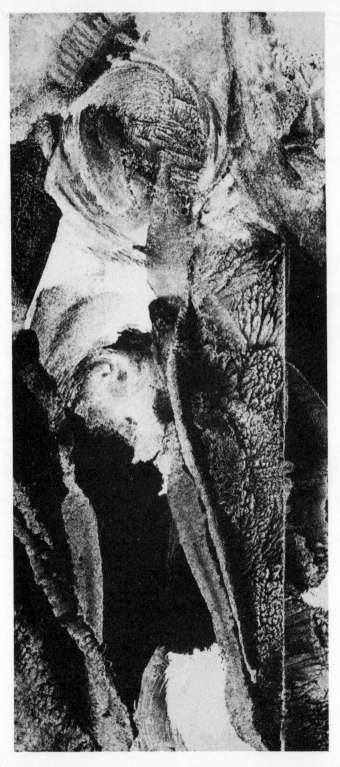

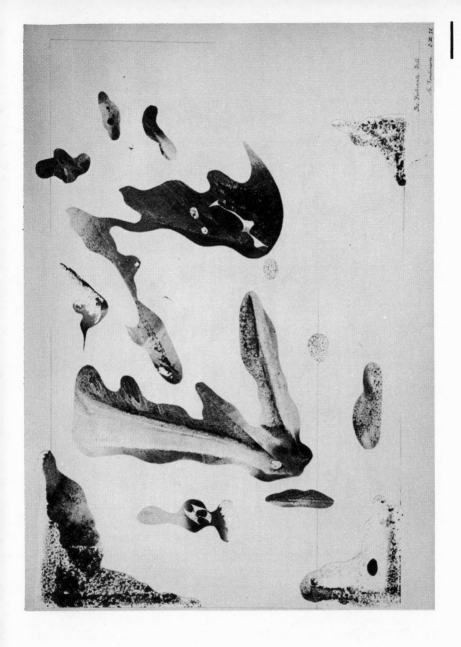

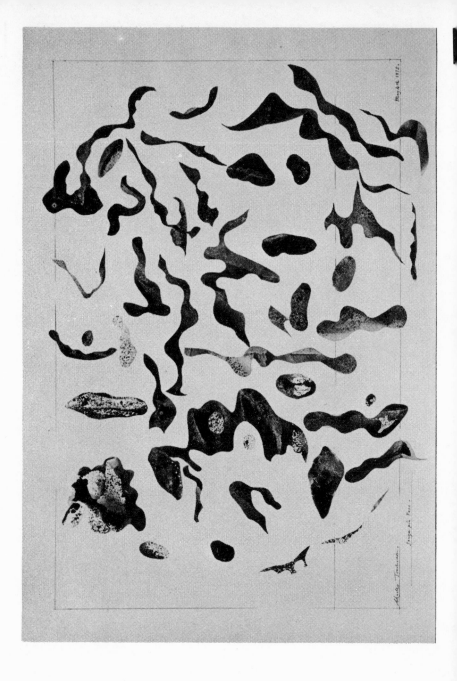

36

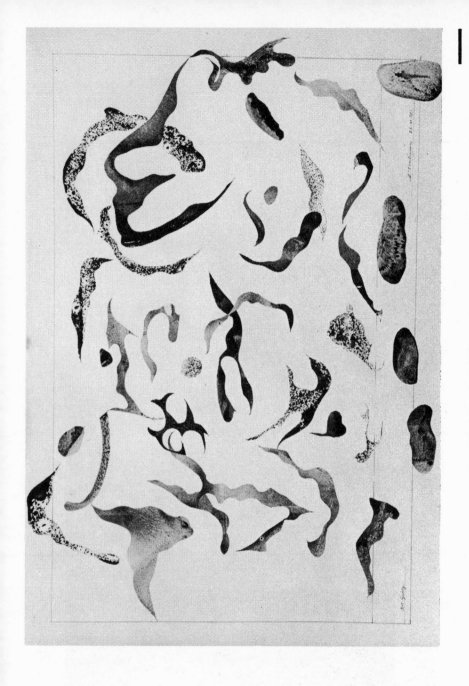

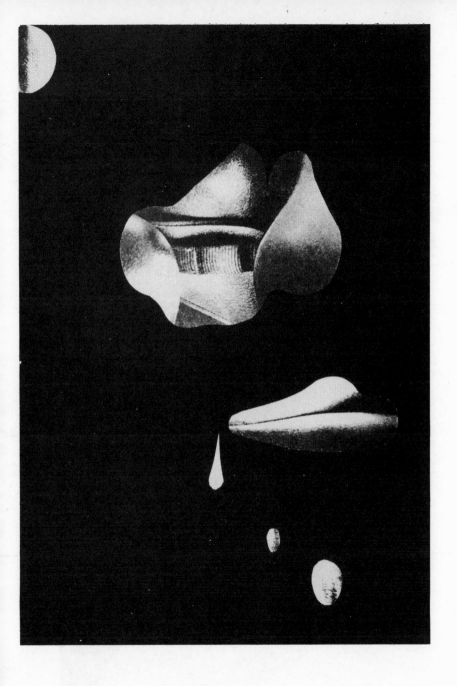

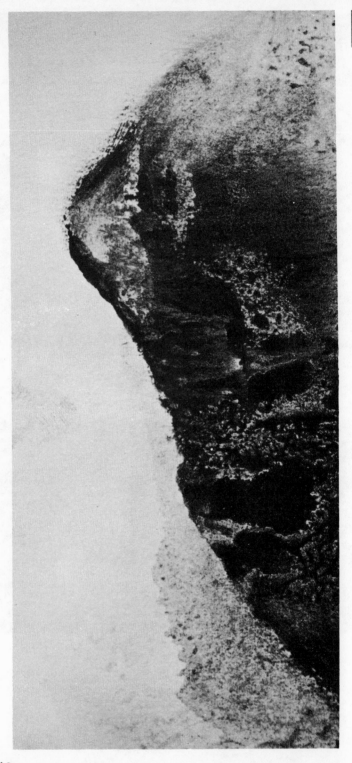

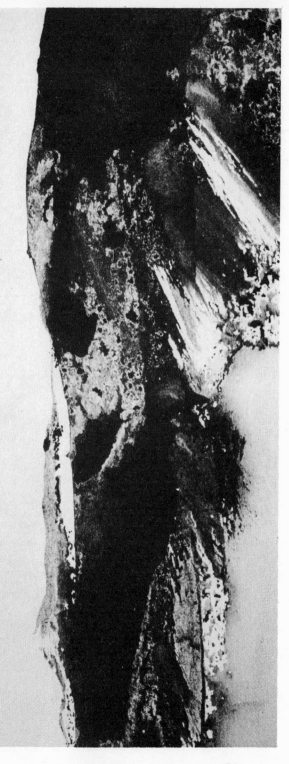

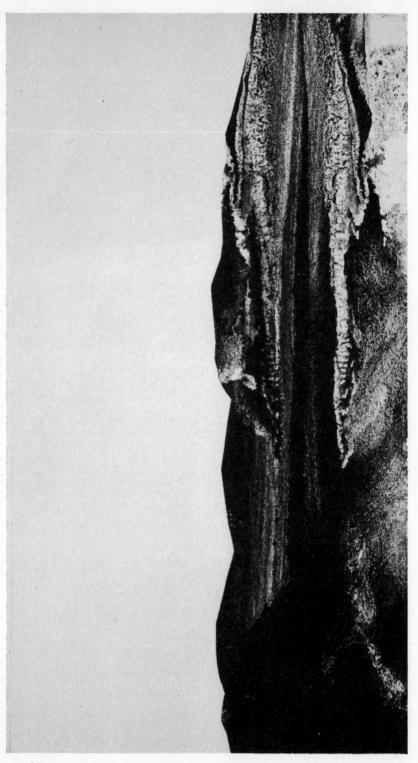

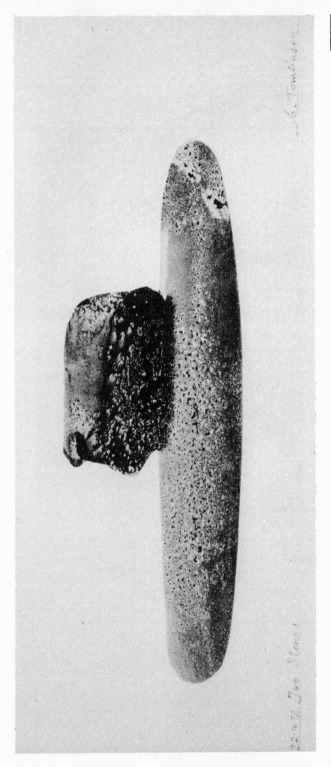

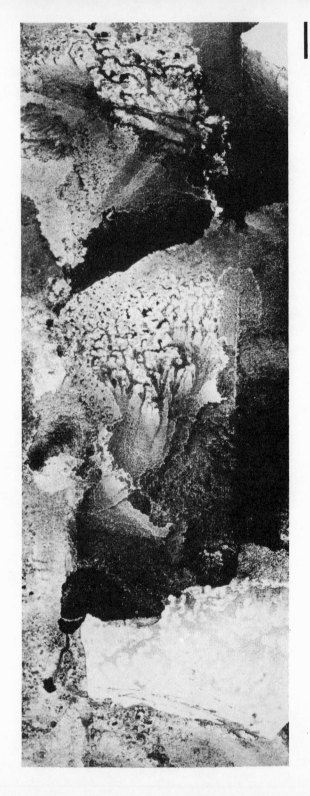

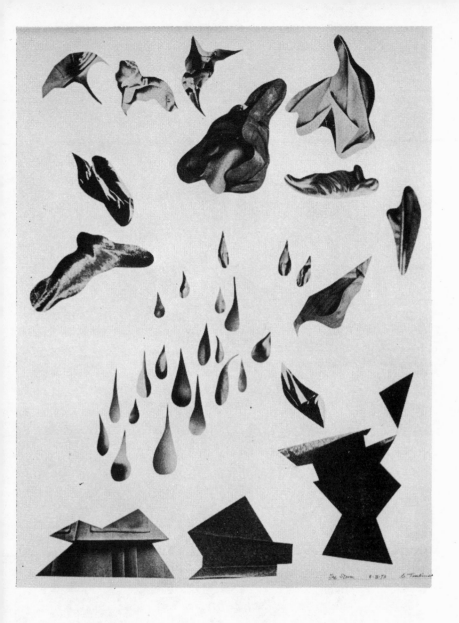

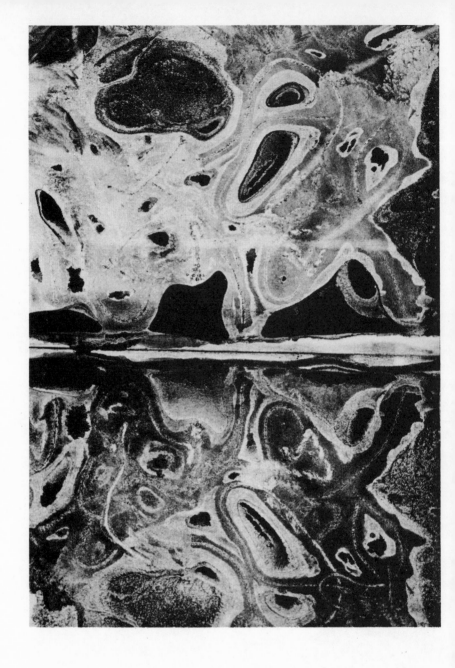

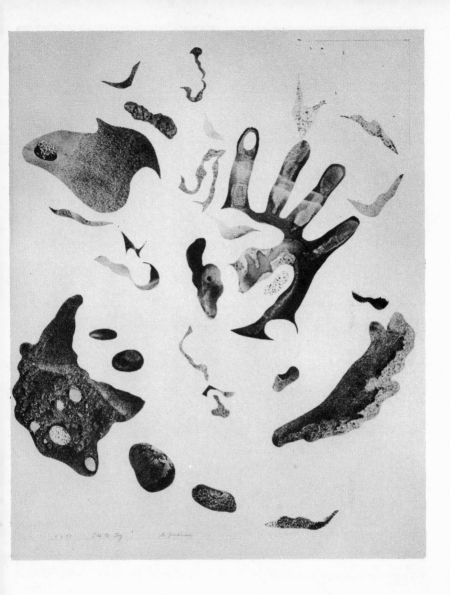

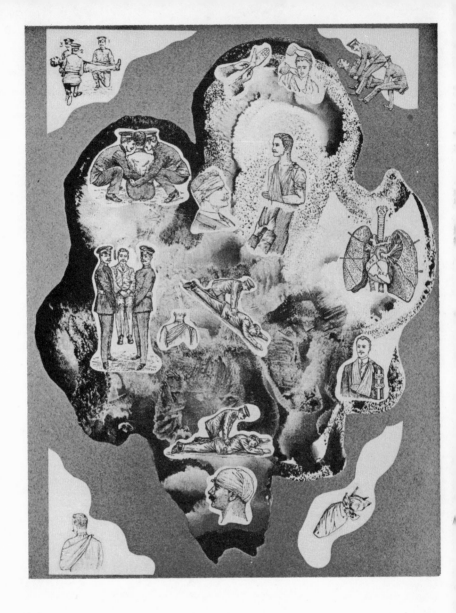

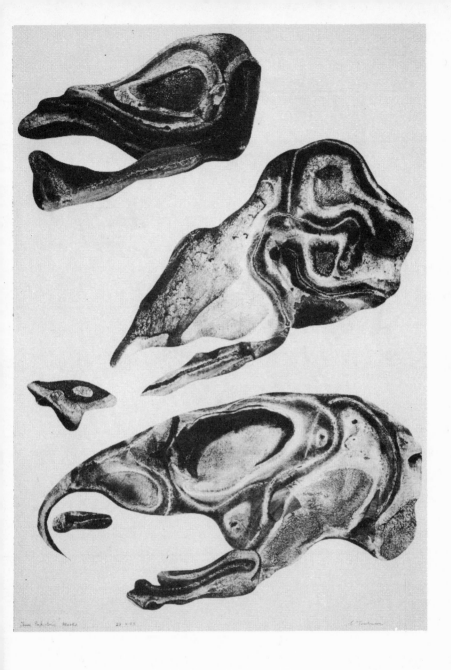

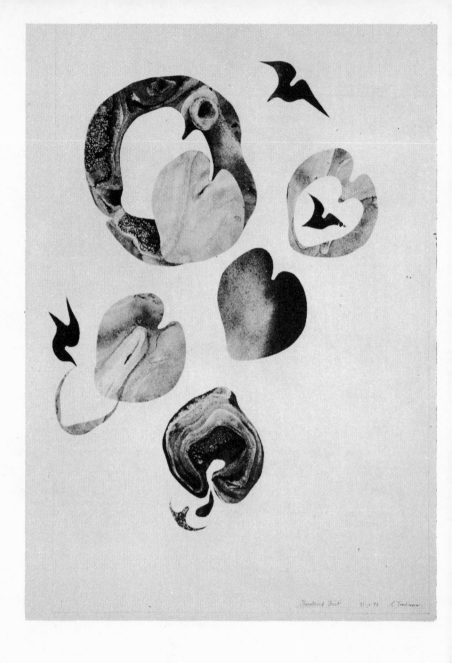

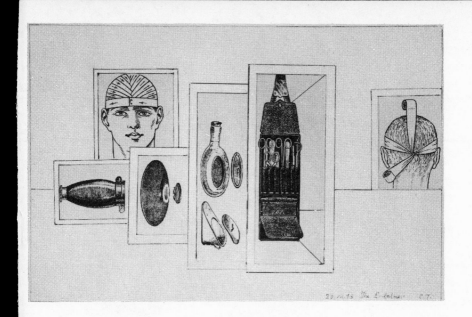

23,14,13 The E. Artman C.T.

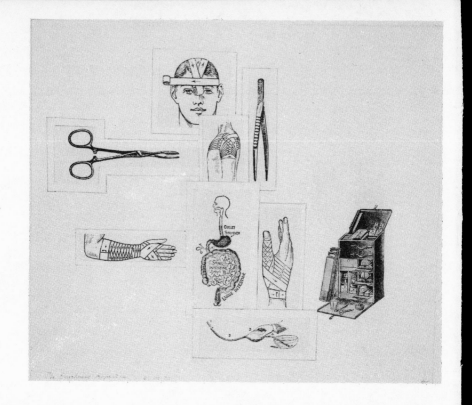

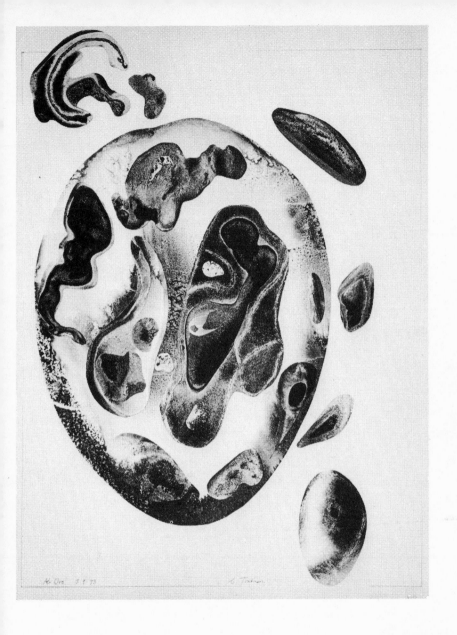